CREEPIOSITY

CREEPIOSITY

A Hilarious Guide to the
UNINTENTIONALLY CREEPY

DAVID
BICKEL

Andrews McMeel
Publishing, LLC

Kansas City • Sydney • London

10 11 12 13 14 WKT 10 9 8 7 6 5 4 3 2

ISBN-13: 978-0-7407-9138-3
ISBN-10: 0-7407-9138-9

Library of Congress Control Number: 2009940860

www.andrewsmcmeel.com

Attention: Schools and Businesses

Andrews McMeel books are available at quantity discounts with bulk purchase for educational, business, or sales promotional use. For information, please write to: Special Sales Department, Andrews McMeel Publishing, LLC, 1130 Walnut Street, Kansas City, Missouri 64106.

INTRODUCTION

CREEPINESS

The American Heritage Dictionary describes creepiness as "Of or producing a sensation of uneasiness or fear: *a creepy feeling; a creepy story.*"

It's the stuff of horror films. The house in the middle of the woods. The killer with the hockey mask. Even the sight of an empty playground. All designed to make us uncomfortable.

But what about all the *unintentionally* creepy things we come across that give us a similarly uneasy feeling? Miniature ponies. Canned deviled ham. The preschool that's really someone's house with a badly painted picture of Mickey Mouse on it.

That's what *Creepiosity* is all about.

The Science of Creepiology

The relative level of creepiness in a particular subject is determined using the science of creepiology. People often ask me, "Come on, is creepiology *really* a science?" To which I usually scowl and patronizingly ask, "Is *biology* a science? Is *physiology* a science?" Obviously, if it ends in "-ogy," it's a science, you numbskull!

I studied creepiology for four years at Yale University. (In retrospect, I should've realized sooner that it wasn't the real Yale University that's in Hartford or Stamford or wherever it is. This one was in Passaic. And it was actually spelled "Y-A-I-L." Fool me once, huh? Ha ha.)

Then it was off to Printston for my master's, where I studied under the great Edgar P. Reisdorf, who first concocted his breakthrough Creepiosity Index in 1947. Since then, creepiness has been measured on a 0–10.00 scale: The higher the number the creepier it is. (And it should be noted that no one has yet found a perfect 10.00, which in truth would have to be a perfect storm of creepiness—such as, perhaps, a tattoo on Janet Reno's back of a ventriloquist dummy biting a pygmy whose right eye is actually a mole with some hair growing out of it.)

Pinpointing the Creepiosity Index is no easy task. To get an accurate number, my team will take a group of several dozen "volunteers" and strap them to a special sensory device (which, ironically, is pretty creepy in and of itself). A picture of the subject in question is projected on a screen in front of them, and then we implement this formula:

$$X \times Y = Z + (0.10C)$$

X = The measurement of how many hairs per square inch stand up on their necks.

Y = The number of times they wince at said pictures.

C = Add 10 percent if there's a clown involved.

And they say creepiology isn't a science. Pish posh!

YOUR FRIEND'S GRANDMA

Growing up, we all had a friend whose grandmother—always from "the old country"—lived with them. She was unnaturally small, spoke weird, and wasn't called "Grandma" but instead something off, like "Minky" or "Ya Ya."

You were always unfailingly polite in her presence for fear if you did something she didn't like she might point her bony finger in your direction and put some kind of spell or hex on you.

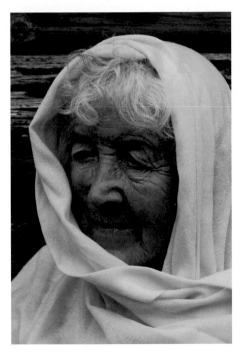

Minky is thinking about turning you into a toad.

CREEPIOSITY INDEX: 9.40

YOUR GRANDMA

Come on, you know it's true.

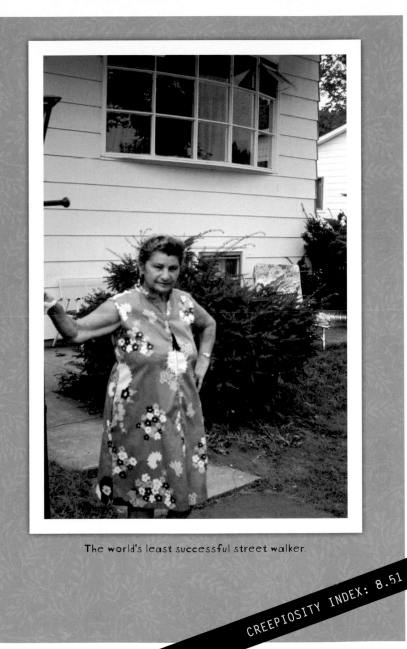

The world's least successful street walker.

CREEPIOSITY INDEX: 8.51

BAZOOKA JOE

He's a child who clearly had some kind of accident—or worse, perhaps, a tumor—and is now forced to wear an eye patch. It's kind of hard to laugh at the hilarious banter between Joe and the gang when this dark cloud of tragedy hangs over the whole thing.

Plus, there's that mentally ill kid who insists on wearing his turtleneck over his mouth.

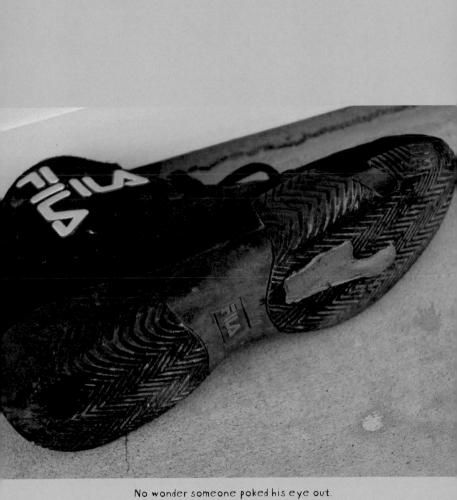

No wonder someone poked his eye out.

CREEPIOSITY INDEX: 7.27

DICK CHENEY SMILING

It's not only because it seems really unnatural, like it's actually hurting his face to give off the illusion of happiness. It's more what it represents, which seems to be a guy thinking: *Perhaps if I "smile," as these people call it, they will trust me to conquer them.*

CREEPIOSITY INDEX: 7.71

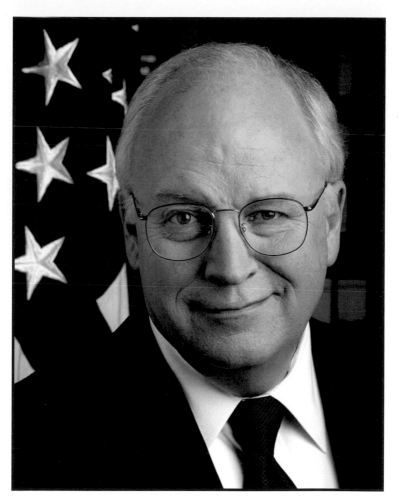

It's actually just a little gas.

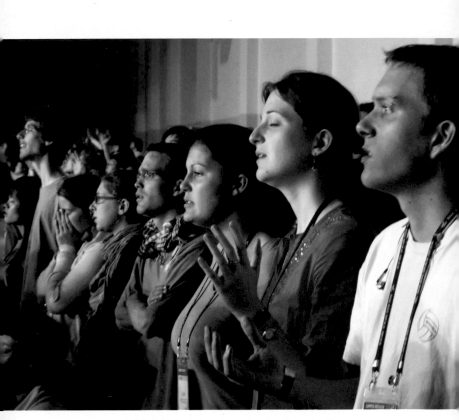

OK, which god are we praying to again?

EVERYONE ELSE'S RELIGION

Every once in a while, you're invited to a wedding that's outside your faith, which means you have to go to some funky building that smells strange and listen to everyone around you chant stuff that makes no sense at all. There'll be some candles, and their leader will inevitably be some guy in a wacky getup, sometimes talking in another language. And there will always be, no matter the religion and without exception, funny hats.

Throw a clown in there, and it'd be the creepiest experience you could ever have.

CREEPIOSITY INDEX: 9.00

YOUR RELIGION

Again, come on. Let's be real about this.

On second thought, this picture might actually be from a Beck concert.

99.9 percent disgusting

BARS OF SOAP

In this futuristic age of "liquid soap," you'll occasionally find someone who still uses a bar in their bathroom sink. Inevitably, it's dirty from the last person who used it and, for some reason, a pubic hair usually manages to find its way onto the thing.

Since I usually only pretend to wash my hands after using the bathroom (I go so far as to run the water then "dry" my hands on my pants as I exit to complete the illusion), this doesn't affect me. But for everyone else who enjoys clean, pubic hair–free hands, this is bad.

THE SONG "MOCKINGBIRD"

No matter how you try to dress it up, it always has a vaguely threatening, ominous element to it. "Hush, little baby, don't say a word." Or what? You're going to skin me alive? You're going to feed me to the monsters under my bed? Sure, you promise me a diamond ring, but for God's sake, I'm a baby! What am I supposed to do with that, except maybe choke to death on it?

If you are gonna buy me a mockingbird,
please make sure to get a gift receipt.

GLINDA THE GOOD WITCH

Conventional wisdom says that the flying monkeys are the creepiest part of *The Wizard of Oz,* but it's time someone slammed his metaphorical fist on the desk and said, "Nay! The creepiest thing in that movie was actually Glinda!"

Think about it: that freaky bubble she travels in; her helium-soaked voice; the way she patronizes the Munchkins, laughing at their fears and apprehensions. Add in the fact that she knew Dorothy could easily go home the whole time but took her sweet-ass time to impart that small detail, and her Creepiosity Index goes through the roof.

I rest my case.

CREEPIOSITY INDEX: 7.02

Glinda, your taxi is here!

THE GUY WHO FIXES THINGS AT THE BOWLING ALLEY

It's happened to all of us. You're bowling, literally having the time of your life, and then all of a sudden the pins don't reset. So you trudge up to the front counter and tell the lady there what's what, and she nods. Next thing you know, some dude with six teeth and skin like one of Burt Reynolds's boots walks over and gives you a look like you did something wrong. You shudder. Then he walks down the gutter and disappears into the bowling netherworld. Minutes later, sure, you're back in business. But the chill hasn't left your bones.

The gang loves Monica's idea to kidnap and torture the bowling alley guy.

CREEPIOSITY INDEX: 9.21

BAND-AIDS THAT WERE ONCE AFFIXED TO SOMEONE'S BODY BUT NOW AREN'T

You see someone with a Band-Aid and you barely think about it—that's part of life. But how about this scenario: You're at Walmart or the library or the "adult novelty" store and you look down on the floor and you see a *used* Band-Aid. Usually with a hint of blood on the cotton part, maybe some hair on the sticky part. If you're a normal person, you react exactly how an elephant in cartoons would if he saw a mouse. You may shriek, you may cower, you may even run.

And it's seventeen times as bad if you see the used Band-Aid in a water fountain.

Actually, a Curad bandage posing as a Band-Aid.

GUYS WITH BEARDS BUT NO MUSTACHES

Simple rule: Mustache without beard, OK. It's a little Village Person/porn star/kid who married his teacher for me, but at the end of the day, it's perfectly fine.

Beard without mustache, on the other hand? Tough to look at.

So please, C. Everett Koop, Gorton's Fisherman, and the guy who sells Christmas trees out of the Vons parking lot on Reseda Boulevard in Los Angeles—add the 'stash or lose the beard. You're making us all uncomfortable.

Rudy ponders life as he stands in front of
Uncle Scrooge's gravestone.

CREEPIOSITY INDEX: 5.75

HAIRLESS CATS

Nobody can argue that hairless dogs are creepy. They remind you of an old Bugs Bunny cartoon, where Bugs blows up Elmer Fudd's dog with some dynamite and he's left, basically, naked (or sometimes, magically, in boxer shorts). But dogs at the end of the day are dogs, a decidedly noncreepy animal.

Cats, on the other hand, are inherently *very* creepy. That's why in horror movies when the woman is in the house alone and it's quiet and spooky and there's a sudden sound it's always a cat—built-in chills.

Now take that creepy cat *and tear all the fur from its body*!

That's a sight you can actually punish small children with.

One word for you Mr. MeowMeow:
Botox.

CREEPIOSITY INDEX: 9.47

LIFELIKE BABY DOLLS

There's a fine line between a cute doll and a creature so realistic that you have to think it must be a real baby that Marie Osmond has somehow frozen in Lucite and is selling for profit.

(Interestingly, Marie wouldn't answer my requests for her to repudiate this charge.)

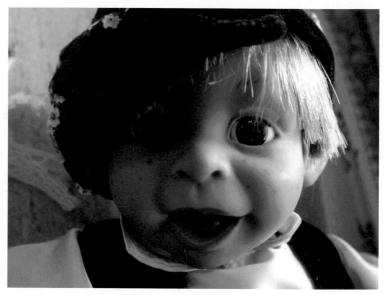

My name is Derek. And I'm going to kill you.

CREEPIOSITY INDEX: 9.22

GROWN MEN IN BOY SCOUT UNIFORMS

Within a group of boys in Scout uniforms, OK; it's not an ideal look, but in context we can allow it.

But when that troop leader (um . . . you are a troop leader, right, fella?) is on his own—say at the bank or a strip club—it's a bit off-putting, to say the least.

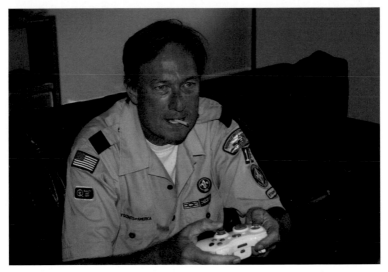

Just a warning, boys: Curtis really knows how to tie a knot.

OWNING MULTIPLE CATS

Here's the math:

1. Owning One Cat: Kinda creepy to non–cat lovers but socially acceptable.
2. Owning Two Cats: This is OK only if you're a middle-aged woman or a gay couple.
3. Owning Three Cats: You've obviously snubbed your nose at society. Your house smells and you probably smell, too.
4. Owning Four Cats or More: Congratulations, you've become *that person*. You're one step away from luring small children into your home and tricking them into your oven.

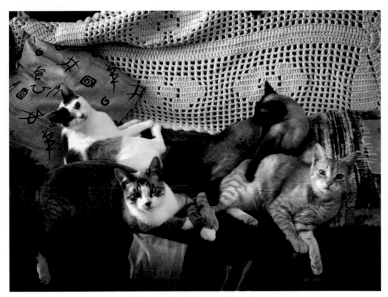

At least they're not hairless.

DISNEYLAND'S "GREAT MOMENTS WITH MR. LINCOLN"

Creepiness-wise, Lincoln was a bundle of contradictions. On one hand, he freed the slaves. Awesome. But he also sported the "beard without mustache" look, which pretty much negated the whole emancipation thing. He ended the Civil War. Very cool. But his wife was cuckoo for Cocoa Puffs. So when the dust settled, pretty much everything on ol' Abe balanced out.

That is, until Disney came along and decided to make a Westworld version of him that's truly disturbing. Keep your Haunted Mansion and your Twilight Zone Tower of Terror; you want to scare a child, make him sit through creepy Terminator-Lincoln for twenty minutes. He'll be sure to have horrible—albeit historically factual—nightmares for years to come.

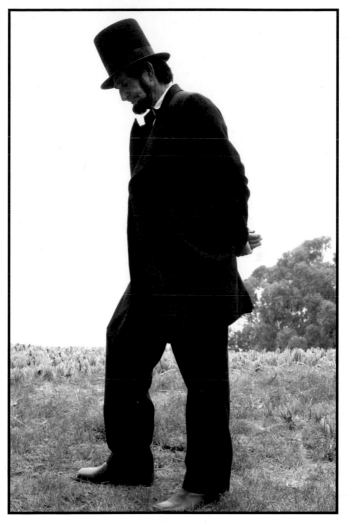

The real Abe Lincoln tries to figure out how he can sue Disney.

CREEPIOSITY INDEX: 9.10

FISH WITH PEOPLE FACES

You go to the local aquarium (or "fish prison" as I like to call it) and spend a few hours looking for the Rolls-Royces of the underwater world, the fish that glow blue. Unfortunately, along the way, you're bound to come across the creepiest of the underwater creatures: the fish with the people face.

They have the nose, sometimes the mustache—I swear to God, I once saw a fish that was the spitting image of my Uncle Irwin. And I'll be honest: Uncle Irwin's face on a human being was never a walk in the park. But on a fish? Horrifying.

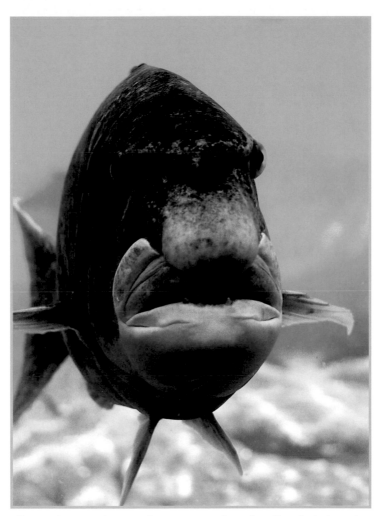

George is angry because he just swam through a pile of whale turds.

CREEPIOSITY INDEX: 8.91

PETTING ZOOS

You take the kids to these things always thinking *This one will be better. This one won't have the same six smelly goats. This one won't have the chickens* (which, by the way, are great fun to pet!). *This one won't have the mule with the doody permanently caked into its hair.*

But it's always the same, always horrifying, always a whole bottle of Purell when you're finished.

Add in the heavyset carny-wannabe who sells the Dixie cups of feed pellets (sometimes with doody permanently caked into *her* hair), and the whole experience is a complete disaster.

CREEPIOSITY INDEX: 8.88

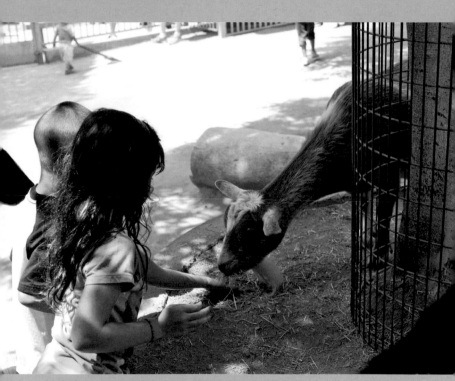

Amanda has no idea that she's fattening Leonard up
to become billy goat burgers later tonight.

ANIMAL MASCOTS WHO WANT YOU TO EAT THEIR KIND

Many times on a sign for a fast food joint there's a mascot cow who's pitching hamburgers or a pig who wants you to eat some yummy smoked ribs, which is wrong in so many ways:

1. I don't need to be reminded that I'm eating an animal.
2. Much less a cute animal in a jauntily askew chef's hat.
3. Much less an animal that's clearly suicidal.

It's so disturbing it almost makes you want to become a vegetarian.*

*If not for the fact that adorable, suicidal pigs are dee-lish!

"Mmmmm, I smell bacon!"

CREEPIOSITY INDEX: 7.80

RED-ASS MONKEYS

As a rule, monkeys are creepy: the people-like hands, the habitual feces flinging, the fact that at any moment they might tear your testicles off.

The creepiest of the creepy are the red-ass monkeys, who appear to be angry and resentful toward all of us with normal-colored asses.

Some might argue that the creepiest monkeys are the ones with the giant Jimmy Durante noses, but that's absurd. I'm talking about monkeys with *big red asses*!

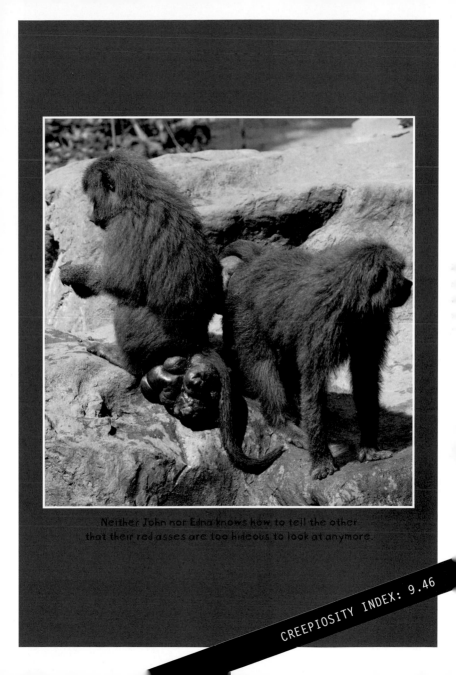

Neither John nor Edna knows how to tell the other
that their red asses are too hideous to look at anymore.

CREEPIOSITY INDEX: 9.46

SEA MONKEYS

In the comic book ads, you're led to believe that you're getting a whole family of creatures who enjoy nothing more than dressing up, hanging out, and playing games with you. It's like buying an entire group of friends for $3.99.

Here's what you actually get: a packet of tiny eggs that you have to "hatch" by mixing them with water (like making the skeeviest Lipton iced tea of all time). And when they do hatch, are they a fun-loving family like in the ads? No, sir. All you end up with is a glass bowl filled with a million gross, floating pieces of protozoa.

Who, by the way, *hate* it when you try to dress them up.

CREEPIOSITY INDEX: 7.14

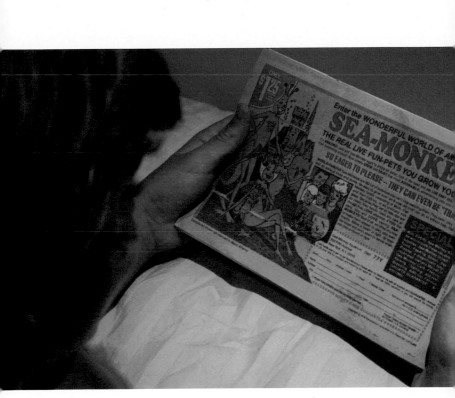

Even worse are the red-ass sea monkeys.

OLD-TYME PORN

As you, above anyone else, know, there are all kinds of different porn on the Internet for every different taste: young, old, black, white, midget, nonmidget, etc. Among the most interesting is the porn from the silent movie era. Just imagine, you could be beating off to the exact same porn that Babe Ruth did. As a baseball fan, that's pretty damn cool.

But before you finish the job, there are two things to remember about what you're watching:

1. Everyone in it is dead. Slightly arousing? Sure. But also a little creepy.

And, more important . . .

2. *That's someone's grandma doing the Victrola repair man!*

Think about it: Somebody is out there watching these films on the Internet, squinting at it, and saying to themselves: "Is that my Ya Ya?"

Pretty disturbing.

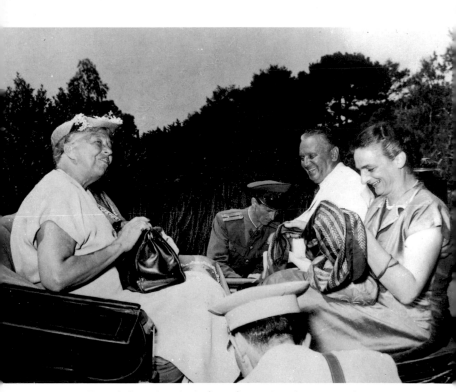

Enough foreplay, let's fast-forward to the money shot.

THIS GUY

He was in every movie in the '80s, yet you don't know his name.

What did you call him?

That Creepy Guy.

Nuff said.

The face that launched a thousand shits.

CREEPIOSITY INDEX: 9.15

AGED-UP
LOST KID PICTURES

Don't get me wrong; it's a tragedy when a kid goes missing. Probably the worst suffering a parent can endure, unless, of course, the kid was a pain in the ass, then maybe a little less so. But we can all agree, it's not a great scene.

Unfortunately, though, to make a bad situation worse, someone came up with the technology to "age up" the picture of the missing four-year-old so we can see what he looks like today, at age twenty. And you know what he looks like? *A damn four-year-old with jowls and a mustache!*

Honestly, if the kid is still out there and he looks like that, he's got bigger problems than just missing his mommy and daddy.

TONY RANDALL DADS

Here's the deal: I think it's awesome that you're still shtupping your much younger wife into your seventies, I really do. But for the love of Pete, take some precaution not to knock her up, OK?

A lot can and has been said on this subject ("Hey, you and the baby have a lot in common—you both wear diapers!"), but the creepiness of the situation can be summed up like this:

"Hey Jimmy, how did you spend your ninth birthday?"

"I went to my dad's funeral."

I guess what I'm saying is, keep it in your pants, Larry King.

Julius hopes to live long enough to see Aidan graduate kindergarten.

CREEPIOSITY INDEX: 7.14

PEOPLE WHO HOLD THE HANDSHAKE TOO LONG

It's actually a pretty simple enterprise:

1. Clasp hands.
2. Pump twice.
3. Release.

If it's your dad or someone you haven't seen since you were a kid, you can pump thrice, but that's it. *Let go.*

I was in a business meeting a few years ago and it went like this:

1. Clasp hands.
2. Pump twice.
3. Hold.
4. Pump twice more.
5. Hold.
6. Hold more.

He was the alpha shaker, so I was really at his mercy, and when the dust settled (and this is true, I swear to God), *he did not let go of my hand for a full minute.*

Now when I know I'm going to see this guy I always have to make sure I have something in my right hand before I approach to avoid the shake altogether. ("Hey Pete, can't shake, busy pulling my pork!")

See also: Too-Long Man Hugs.

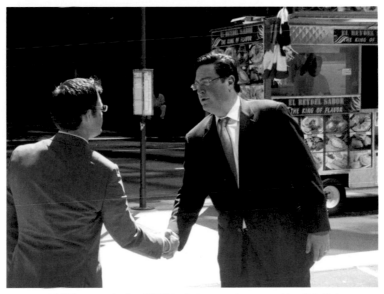

All Bill wants is for Cliff to let go so he can get a falafel.

LITTLE KIDS WITH OLD-PEOPLE NAMES

Sure, child abuse in the form of beatings and basement imprisonment grabs the headlines, but there's a wider spreading form of child abuse going on all around us: the parents who saddle their kids with old-people names.

Hey, hip, cosmopolitan mom, do you really believe your six-year-old girl is happy to be named Blanche? You didn't think there was any chance your fourth grader might get beaten up because his name is Herbert? They're not "so square they're hip," people—they're just square.

And creepy. Just ask my daughter Gertrude.

CREEPIOSITY INDEX: 6.45

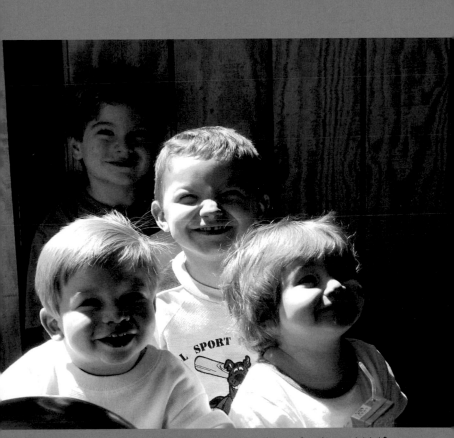

(From top left, clockwise): Woodrow, Milton, Bertha, and Adolf.

THE OTHER PEOPLE IN THE DOCTOR'S WAITING ROOM

Sure, whatever I have is bad. But what they all have is a *nightmare*.

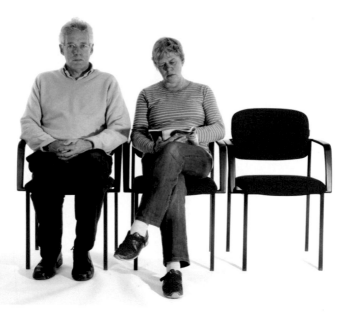

SARS and leprosy, respectively.

CREEPIOSITY INDEX: 9.00

SQUIRRELS THAT LOOK AT YOU A BIT TOO LONG

You're getting some stuff out of the trunk of your car and you feel it—someone is staring at you. You turn around to discover that it's a squirrel. Your eyes meet. Feeling uncomfortable, you turn your glance away but he doesn't. He's locked in. What's his game? Is he going to charge you?

Why shouldn't he? You've run over dozens of his relatives over the years. And even if he dies attacking you, he's probably thinking, "What do I have to lose? I'm a goddamn squirrel."

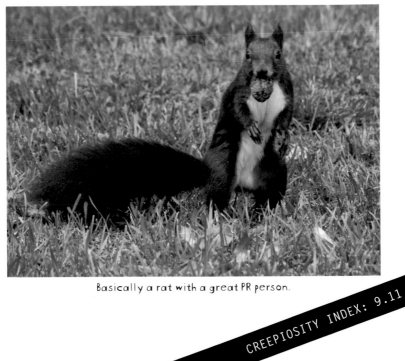

Basically a rat with a great PR person.

CREEPIOSITY INDEX: 9.11

GROWN-UPS WITH PIGTAILS

It's adorable on little girls and can even be kind of cute on a hot twenty-year-old coed. But when you're sixty, it's just plain creepy.

I'm looking right at you, lady who played Elly May on *The Beverly Hillbillies*.

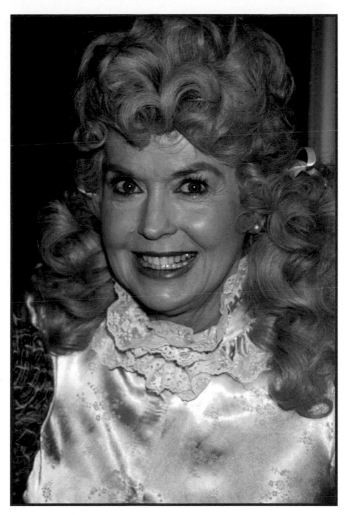

Jethro likes to call them her "love handles."

CREEPIOSITY INDEX: 7.61

"CAN YOU READ MY MIND?"

For me, the 1978 *Superman* movie was a dream come true. Cool special effects, funny bits, the perfect—*perfect*—Superman. For the first half hour I had a smile on my face General Zod couldn't knock off. And then . . . it happened.

There's a real fun scene on Lois Lane's terrace. She's interviewing him, he's peeking at her undies—joyous. He scoops her up and takes her flying around the world. Swoon. But then, all of a sudden—without warning!—*she starts talking but her lips aren't moving.* And it's not really talking, it's kind of singing. But more like talking.

And it goddamn rhymes!

For some reason, we're privy to Lois Lane's thoughts and what she's thinking is a dumb-ass poem about Superman reading her mind!

I know one thing for sure, Miss Lane: If he *could* read your mind and he heard that crazy-ass mumbo jumbo, there's no way he isn't dropping you into the Metropolis River.

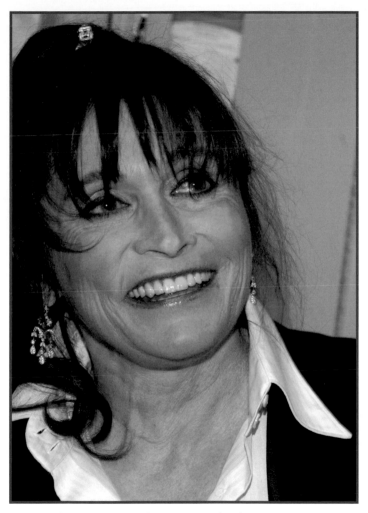

Margot is contemplating putting her hair in pigtails.

CREEPIOSITY INDEX: 8.87

Looks more like egg foo *old*, you know what I'm saying?

CREEPIOSITY INDEX: 6.25

PICTURES OF THE DISHES ON THE WALL AT THE CHINESE TAKEOUT JOINT

The photo of the shrimp with lobster sauce has a small burn mark on the side; somebody has scrawled something pornographic on the barbecued spareribs; the picture of General Tso's chicken has been there since General Tso was actually in power. No matter what, we can all agree that these faded, dirty pictures aren't helping sell any Chinese food; all they're doing is giving customers the creeps.

The calendar with the hot Chinese girls can stay, though.

TOY TRAIN AFICIONADOS

They're like urban legends—we all have a friend who has a friend who has an entire miniature town set up in his basement. With hundreds of little trees and tiny people, all of which would be very disturbing even if they didn't have some strange dude as their god.

And sometimes, lord help us all, he wears the engineer's hat.

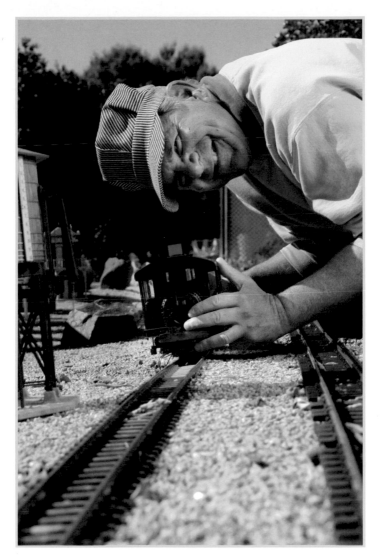

Perry never did understand that people don't like a show-off.

PEOPLE WHO DRIVE
REALLY OLD CARS

Here's the scene: You just got a call from, say, your buddy who knows a jockey who has a sure thing on race number five at Belmont, which goes off in fifteen minutes (you can sub out "your wife is in labor" for a less colorful reason to be in a mad rush). Point is, every second counts. And in front of you, on this one-lane road, is a dude driving a damn 1906 Model K Ford. He's gunning it, going a breezy eight miles an hour. And if he's driving that car, there's always a chance he's dressed for the part, which means goggles and a leather helmet. It was cute on Penelope Pitstop, not so cute on him.

Look, being nostalgic for stuff from when you were a kid is cool. You found a vintage Rock 'Em Sock 'Em Robots on eBay? Hats off to you. But when you hanker for something that was in vogue when your great-grandpa was rubbing one out to daguerreotypes of Mary Todd Lincoln—*liiiiiitle* creepy.

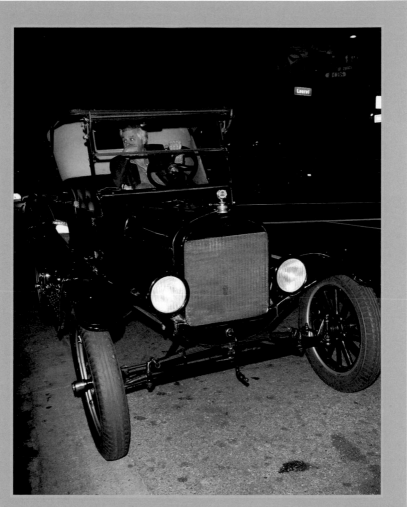

Jay is back on the road after replacing the candle in his right headlight.

CREEPIOSITY INDEX: 6.71

THE NURSE'S OFFICE AT SCHOOL

The wall was littered with posters of teeth with faces and food pyramids and warnings about taking rides from strangers—all from thirty years ago. (That pedophile offering the candy to that little girl is driving a '72 Hornet, for crying out loud. Let's stay with the times!)

And then there was the nurse herself, who was usually trained only to apply a Band-Aid or check for lice. (**Lice-Checking Chopsticks** Creepiosity Index: 7.40.) This was not the place you wanted to be at any point during the school day.

And yet it was still a thousand times better than the boys' bathroom.

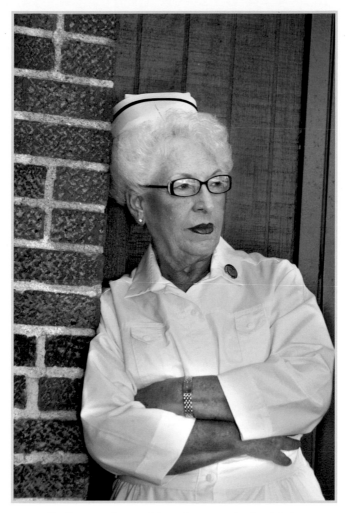

Sheila sometimes wishes she were the lunch lady.

CREEPIOSITY INDEX: 8.28

MR. ROGERS' NEIGHBORHOOD

Sure, it has the reputation of a beloved children's program, but was it *really,* or is that some Kool-Aid we were encouraged to drink?

The fact of the matter is, this was a very unnerving show: Mr. Rogers changing his clothes on camera every episode, that mailman who enjoyed kids a bit too much, those puppets who didn't have moving mouths, just bobbing heads?

Some might say that *Teletubbies* is the most disturbing thing to hit children's television, and that's hard to argue with. But you can be sure that there wouldn't be that baby-head sun and those giggling creatures with nonworking mouths on PBS if Fred Rogers hadn't broken down those creepy doors a generation earlier.

King Friday loves it when Fred's hand is up there.

CREEPIOSITY INDEX: 9.10

LIPSTICK ON ANYTHING BESIDES A WOMAN'S LIPS

I'm not sure if we had a lousy dishwasher when I was growing up or if my mom was a bad homemaker (probably both), but any time Judy Goldblatt came over for mah-jongg (**Mah-jongg** Creepiosity Index: 8.76), it was a sure bet that we would not only find lipstick-stained cigarettes all over the place (**Judy Goldblatt** Creepiosity Index: 8.31), but also a coffee mug stained with the stuff for days after.

As a result, to this day I never smoke, drink coffee, or wear anything but smear-proof lipstick.

Note to self: Buy Mom some Cascade.

CREEPIOSITY INDEX: 8.02

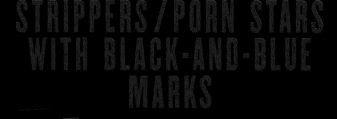

STRIPPERS/PORN STARS WITH BLACK-AND-BLUE MARKS

If I had a daughter, I'd give her this advice from a very early age:

> If you're going to exhibit your body professionally, it should generally be free of bruises, cuts, wounds, scars, and abrasions. If you need to put a Band-Aid on your body, maybe you should take a day off.
>
> Furthermore, if you have a large birthmark, you might want to look into a different vocation.

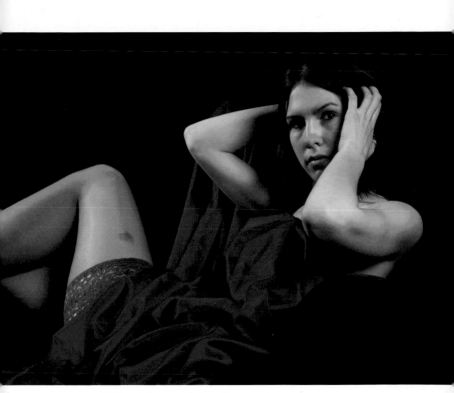

At least Savannah has the courtesy to cover up
the burn marks on her ears.

CREEPIOSITY INDEX: 7.89

BRUCE JENNER'S FACE

There's something that happens to a man's face when he gets plastic surgery—he starts to look like a woman. Kenny Rogers, Burt Reynolds, Donny Osmond—they're almost unrecognizable as the men they once were and now, instead, they all resemble chicks.

Creepy, creepy, chicks.

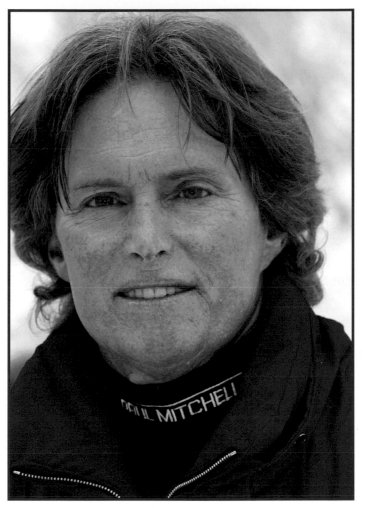

I still own her Wheaties box.

MOM-AND-POP SUPERMARKETS

First of all, let me just say three cheers to them for not buckling to the corporate fat cats. That's something to be admired.

That said, the whole experience—the wooden floors, the small variety of (dusty) food, the cash register that may or may not have that "no sale" key—all pretty creepy.

Give me a sterile environment and seventy kinds of corn flakes and the sweet carcinogenic hum of fluorescent lights, and I'm a happy man.

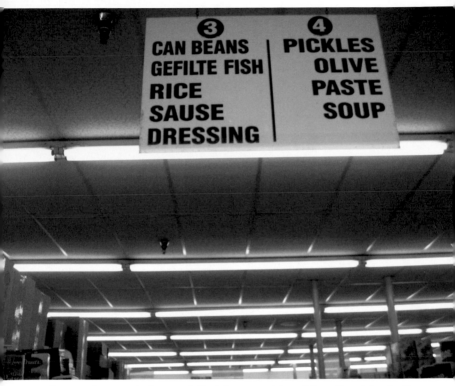

3
CAN BEANS
GEFILTE FISH
RICE
SAUSE
DRESSING

4
PICKLES
OLIVE
PASTE
SOUP

How much paste do they sell that they need to put it on the aisle sign?

THE GUY ON THE STREET WALKING FAST AND CARRYING A BACKPACK

Doesn't matter if there isn't a hooker's head in there, we all assume there is.

Slow down, Chief, you're giving us all the creeps.

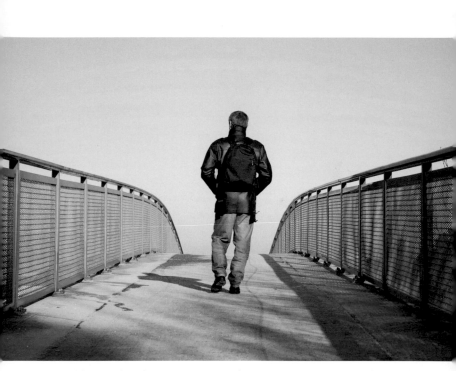

Mike just bought some sause at the mom-and-pop supermarket.

SID AND MARTY KROFFT

H.R. Pufnstuf, Lidsville, Sigmund and the Sea Monsters, Land of the Lost. These people terrorized us when we were kids, and do we hold it against them? No, we treat them like heroes.

You should thank the heavens that I have the guts to say it out loud: That was some creepy shit.*

*Although I have to admit that I do enjoy these shows tremendously when I'm hopped up on my magic mushrooms.

CREEPIOSITY INDEX: 9.04

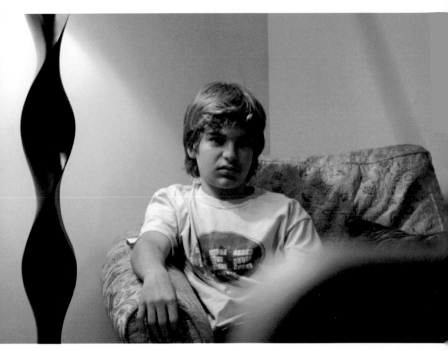

Camden watched, secretly hoping for a Witchiepoo nip-slip.

Grandma's favorite snack.

BINGO ZEALOTS

This is America, and that means people have the right to express themselves however they see fit. For some, it's denouncing the country and its policies and citizens; for others, it's marching while shouting racial epithets and burning effigies. But far creepier than either of these is the Bingo Zealot.

Let me start by saying I think it's great that the weak-minded have a game they can enjoy. My grandmother loved it, even though toward the end she seemed to think the plastic bingo chips were mints because a lot of them went missing when she played (and, by the way, it never helped her herring breath).

But even though my Ya Ya loved the game, she didn't love it so much that she felt the need to advertise that fact. Did she wear a sweater that bragged "Bingo night for me . . . TV dinner night for you!"? No, she didn't. Did she carry around a seat cushion that made it comically clear that she played bingo only on "days that end in Y"? Never once. Did she ever sport hilarious "O69" earrings? OK, that she did do, but only because I gave them to her and she had no idea about the double entendre (and it should be noted that she ultimately ate them thinking they were gum balls).

It's OK to enjoy something—nay, it's *great* to enjoy something—but to brag that much about loving something that is so (and this may sound snobbish) moronic . . . that's a little creepy.

CREEPIOSITY INDEX: 7.40

POPEYE

Here's the basic premise of every episode of Popeye:

Popeye has to rescue Olive Oyl from being raped by Bluto.

That's not creepy at all, is it kids?

Throw in the fact that the guy mumbled like a mental patient, he liked punching cows so hard that they flew up in the air and turned into a butcher shop, and he had three identical "nephews" and yet had no discernable siblings, and the whole thing is quite disturbing.

"Well, blow me up!"

HBO'S *REAL SEX*

This is a show that's on HBO a lot, and it's almost impossible to watch without cringing.

Listen, I respect other people's quirks and peccadilloes and fetishes,* but that doesn't mean I need to see it on TV.

If elderly masturbation parties, sex with stuffed animals, and role play in which someone is a horse and someone is a jockey is something that turns you on, I say God bless,† but for the rest of us, this be creepy.

Paul is enjoying getting "elfed."

*I actually don't.

†I am, in fact, judging you pretty harshly.

CREEPIOSITY INDEX: 7.77

ANDY ROONEY'S EYEBROWS

"You ever notice that normal human beings don't let their eyebrows grow all wild and Grinch-like, especially when they know they're gonna be on TV every week for sixty years?"

One of Andy's eyebrows is getting away!

CREEPIOSITY INDEX: 7.55

OPERA SINGERS

Nobody can deny that these are talented people. Being something of a saloon singer myself, I have nothing but respect for these artists. But do they have to wear all that makeup? And honestly, when the company is going on a Taco Bell run, would it kill them to say "No, thanks" once in a while?

Plus, they usually sing in some foreign language.

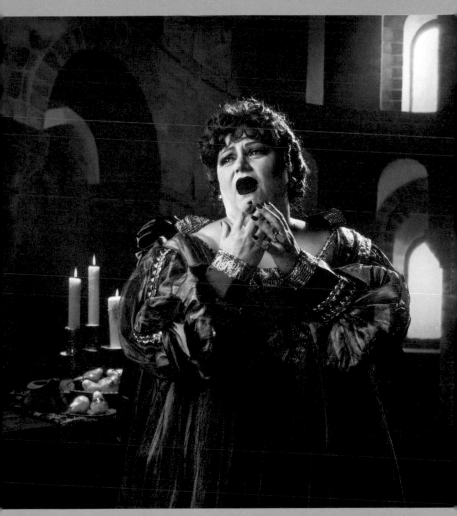

Greta is mulling an offer from Jenny Craig.

CREEPIOSITY INDEX: 7.55

KIDS ON LEASHES

I've never won Parent of the Year,* but I do know that putting your kids on a leash is a sure way to screw them up big time. Think about it—who is generally on a leash?

- Dogs
- People who practice S&M

Now I love dogs and I love S&M (but hardly ever at the same time). What I don't love is seeing kids being pulled into the Cinnabon by a woman who looks like the mother from *Million Dollar Baby.*

If you want to leash your kids, do us a favor: Keep it at home, where it belongs.

*I was awarded World's Greatest Dad by my son when he was five, but I ended up smashing the mug against the wall when he wouldn't finish his baby carrots.

Katie is constantly stopping to sniff other toddlers' butts.

CREEPIOSITY INDEX: 8.68

THE UNCLE WIGGILY GAME

Somehow, people remember this game fondly. Not me. Here's why:

1. I've learned the hard way that saying "Hey, kids, let's play the Uncle Wiggily Game" can get you on the sexual predators list.
2. The game is full of rhymes. You know what else is full of rhymes? Witches' spells.
3. Uncle Wiggily is a rabbit in a top hat. Where does a rabbit get a top hat? From the magician he killed.

Uncle Wiggily sucks.

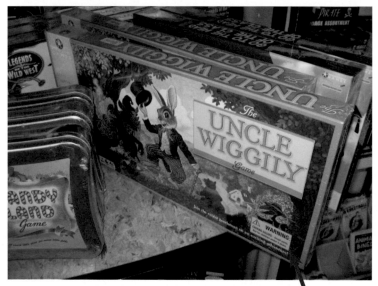

Added bonus —now also a choking hazard!

CREEPIOSITY INDEX: 7.62

DAVEY AND GOLIATH

A Claymation show about a religious kid and his talking dog produced by the Lutheran church.

Nah, not creepy at all.

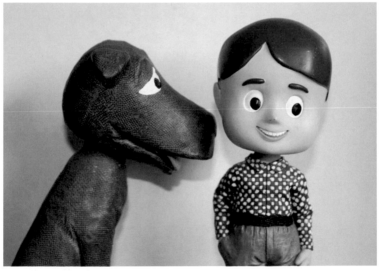

"Gee, Davey, you know the Jews control the world financial market."

CREEPIOSITY INDEX: 9.18

GUYS WHO LOOK LIKE SANTA CLAUS
(WHO AREN'T THE ACTUAL SANTA CLAUS)

One of the greatest ironies is that a random guy who looks like Santa Claus is actually the last person on Earth you'd want anywhere near your kid.

Much less let them sit on his lap.

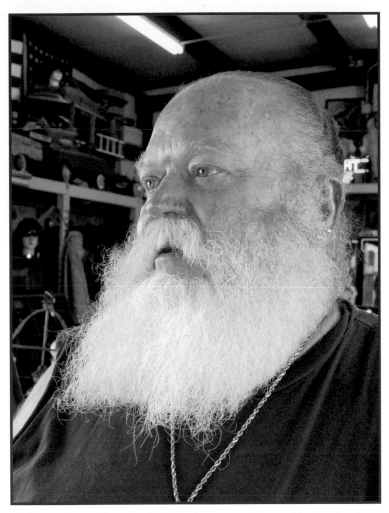

Ed hopes you realize that "Coming down your chimney" is a euphemism.

CREEPIOSITY INDEX: 9.07

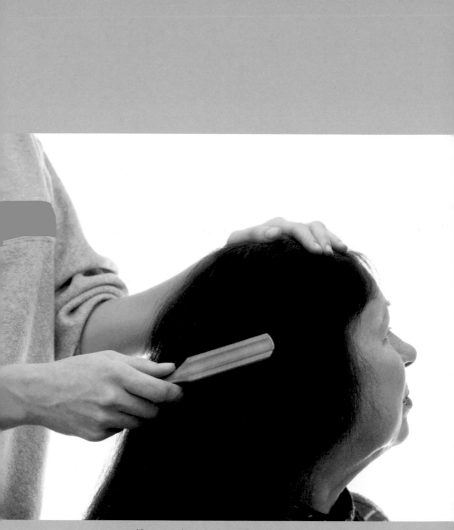

Yet another Crystal Gayle wannabe.

OLD LADIES WITH REALLY LONG HAIR

There's nothing worse than when you see the hottie from behind and she turns around and you find yourself face-to-face with Cloris Leachman sporting Megan Fox's hairdo.

I guess there is something worse: Making out with her anyway.

MEN WITH VASTLY UNREALISTIC DYED HAIR

When our forefathers invented Just For Men, their goal wasn't to shock or upset; no, they wanted to help society by adding a subtle, slightly darker hue to assist gray-haired gentlemen in looking a little bit younger (and, naturally, help them get laid). Noble intentions, indeed.

Unfortunately, the idea of "subtle" has gotten away from some fellas. The result? Creepy-looking eighty-year-olds with jet-black hair. Usually accompanied by jet-black eyebrows and the dreaded jet-black beard.

Here's the tough truth, Grandpa: Not one person is looking at you with your crazy Kiwi-shoe-polish hair and saying, "Say, who is that young hotshot? A college lad, perhaps?"

And, scariest thought of all, have they made the carpet match the drapes?

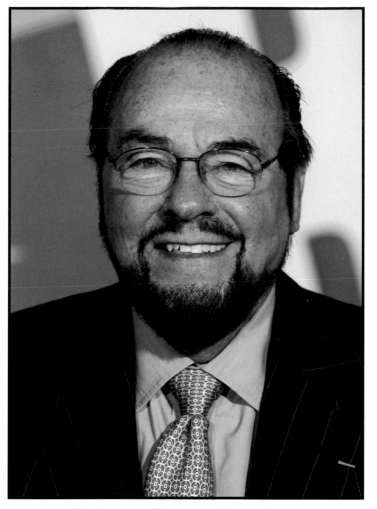

In the words of the immortal Bernard Pivot:
"Sacrebleu, that eez a bad dye job!"

CREEPIOSITY INDEX: 8.10

ANY HALF PERSON /
HALF ANIMAL

I was sitting around with a bunch of my friends watching a baseball game when my buddy Dennis, out of nowhere, in a soft southern drawl said:

"Any half person/half animal . . . I hate that shit."

Naturally, it quieted the room since we were talking about the Mets middle relief at the time, but it struck us, despite how random the statement was, that it was true: We all hate that shit.

The Minotaur, the centaur, the Sphinx—all really, really creepy.

And I have to agree with what Dennis later said:

"I'm glad they're all extinct."

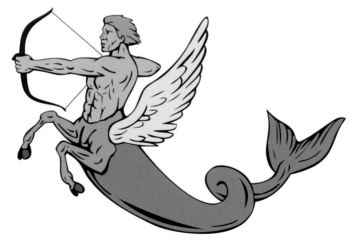

Excuse me half man/half horse/half bird/half fish—
you forgot your arrow.

CREEPIOSITY INDEX: 8.99

THE DRIVE TO THE SERVICE STATION WITH THE TOW-TRUCK GUY

Sure, you try to fill the time with small talk:

"So, you fix a lot of flat tires, huh? That's awesome."

But all the while you're thinking this:

"Please don't take me into the woods, chop me up, and bury me in a shallow grave."

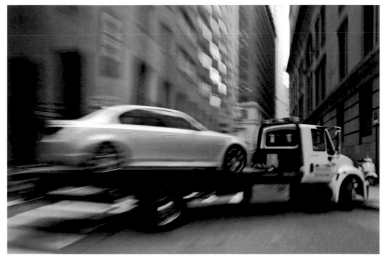

Pete is in a hurry to kill this guy and get home in time to catch *Idol*.

CREEPIOSITY INDEX: 8.50

LILY TOMLIN AS THE LITTLE GIRL IN THE BIG CHAIR

Lily Tomlin gets the needle on the Creepiosity scale moving a little just for being Lily Tomlin. Now dress her up like a little girl. Then make her talk, for some reason, like she has a cold. And finally, put her in a giant rocking chair.

The only question is, why has society not put this right up there with Hannibal Lecter and Freddy Krueger?

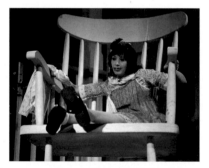

Yet still less creepy than that freakin' operator character.

PEOPLE WHO ARE FLUENT IN MADE-UP LANGUAGES

I took Spanish for four years in high school and I can barely order a chalupa at Taco Bell, while there are people out there who can recite the complete works of Shakespeare in Klingonese.

It would be easy to glean from the above that I'm a moron and that those Klingon-speaking people are ambitious and dedicated, but I prefer to mock them as weirdos and losers.

Bottom line is, if you want to learn a second language, more power to you. And if it's a silly language like Klingonese or Ubbi Dubbi or Swedish, that's cool, too. But showing it off to the world isn't impressing anyone; it's just making our *gik'thor** hurt.

Q'Nom never misses *The View*.

*"Stomach" in Klingonese.†

†It may actual mean "corkscrew."

CREEPIOSITY INDEX: 8.12

COLONIAL WILLIAMSBURG

I figured this one out on a school trip when I was in fifth grade: People dressing up in historical garb—and this is the crucial part—*never breaking character*, is a first-class ticket to Creepyville.

Look, I think it's great if you found a gig where it's finally socially acceptable for you to walk around dressed like Benjamin Franklin. But do me a favor, if I ask you where the bathroom is, don't tell me "Being ignorant is not so much a shame, as being unwilling to learn." Tell me where the men's room is before I pee all over your stupid knickers.

CREEPIOSITY INDEX: 9.06

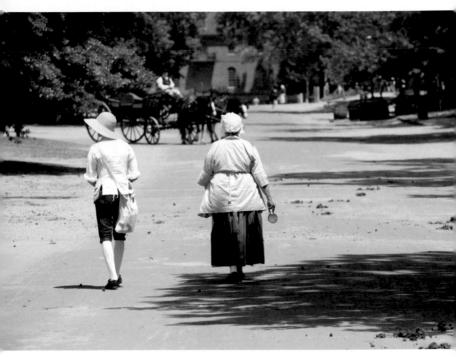

I hate to see thee go, but I love to see thee walketh away.

RENAISSANCE FAIRS

Creepy people in creepy costumes re-creating a creepy period in history. Basically, these are the people who think working at Colonial Williamsburg is for "weirdos."

But the giant turkey legs are pretty awesome.

Richard Dreyfuss figures "An acting job is an acting job."

CREEPIOSITY INDEX: 7.62

GRANDMA CANDY

I've never been sure where grandmas shop for candy, but it can't be anywhere in the United States. Here's what's on the hit parade of every grandma candy dish I've ever encountered:

1. Something wrapped in colored cellophane in the shape of a raspberry (but tasting nothing like one).
2. Something way too small that tastes like licorice.
3. The round hard candy ball that's the exact size of a five-year-old's windpipe.

Is this a conspiracy? Why don't old people stock up on candy that's good? Does the AARP also own the Way Too Small Candy That Tastes Like Licorice company?

I will get to the bottom of this. I may have to seduce your grandma to get some answers, but rest assured, the world will find out the truth.

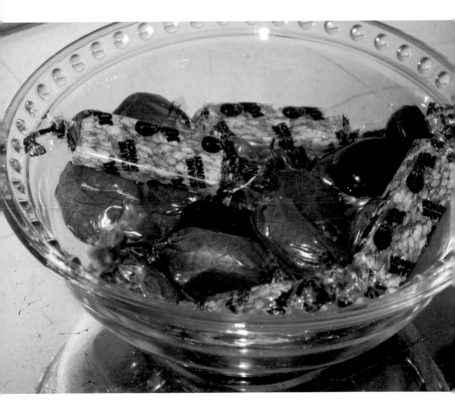

Thankfully, Ya Ya used to screw Dr. Heimlich.

THE GOOD HUMOR MAN WHO'S A BIT TOO CHUMMY

In my neighborhood, we had the same ice cream man for the first twelve years of my life. Our relationship was very professional: I hand you money, you give me a Bomb Pop, and that's that. I don't want to know your name, you don't need to know my name. A simple business transaction, nothing more, nothing less—kind of the kid equivalent of soliciting a prostitute (not that I would know anything about that).

But after he disappeared, along came Charlie. Fun Charlie. Friendly Charlie. Everybody's pal Charlie. Charlie was like, "Hey kid, you want a napkin?" and "Please put the garbage into the dragon's mouth, buddy." In other words, a little too touchy-feely for my taste.

I'm not here to make friends, guy. I'm here for a damn Fudgsicle.

CREEPIOSITY INDEX: 8.16

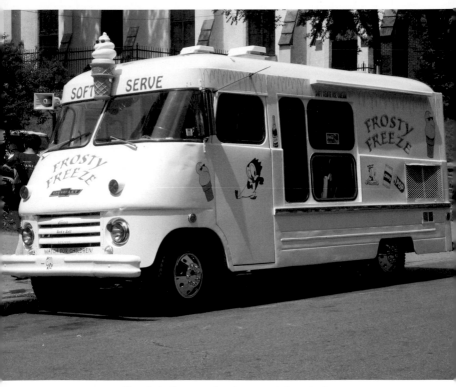

Charlie's freezer is also great for storing
the bodies of kids with big mouths.

PEOPLE WHO GO TO HIGH SCHOOL FOOTBALL GAMES WHO DON'T HAVE A KID AT THAT SCHOOL

Only three kinds of people without a kid at the school would go to a high school football game:

Group A: People who went to the school and still feel a connection to their alma mater.

Group B: People who live in the neighborhood and want to support the local kids.

Group C: People who are sociopathic John Wayne Gacy–esque perverts who like nothing more than to watch young boys in tight pants grab one another.

Since we're always gonna assume you're in Group C, it's probably best if you folks in Group A and Group B stay away, too.

CREEPIOSITY INDEX: 8.99

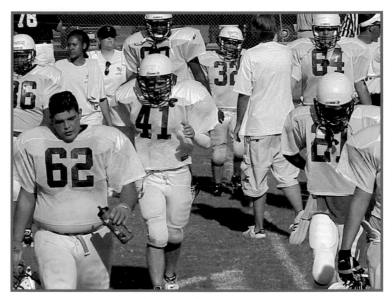

Welcome to Gacy Heaven.

PRECIOUS MOMENTS

Does anything more need to be said than this?

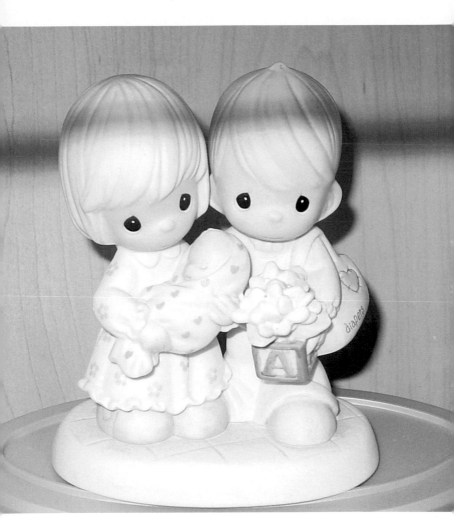

Charlie and Dina are clearly suffering from postpartum depression.

PEOPLE WHO MAKE THEIR MAIDS WEAR THE MAID UNIFORM

Here's the deal: If your intent is to make your maid wear the uniform because you want to sexually harass her while she dusts your collection of Precious Moments figurines, then I say more power to you.

But if you're making her wear the uniform to emphasize the difference in status between you and your "help," then that's plain creepy.*

*It should be noted that I almost always allow my butler to lose the suit and dress "California casual," except on special occasions, such as when my scrapbooking club gets together or when I want to impress my lodge brothers.

CREEPIOSITY INDEX: 7.03

She has one arm and you still make her wear the uniform?

THE BLOWY GUY IN FRONT OF THE MATTRESS STORE OR CAR DEALERSHIP

A few years ago, someone got the bright idea to put an air-powered flailing stick man in front of businesses to attract attention. Besides the fact that this creature looks like a tortured spirit just released from the Lost Ark, let's think more practically:

Has one person ever, in the history of these things, driven by and seen one and said, "I had no interest or need for a car, but after seeing that freakish monstrosity—hell, I'm gonna stop in and buy me the most tricked-out Kia they make!"

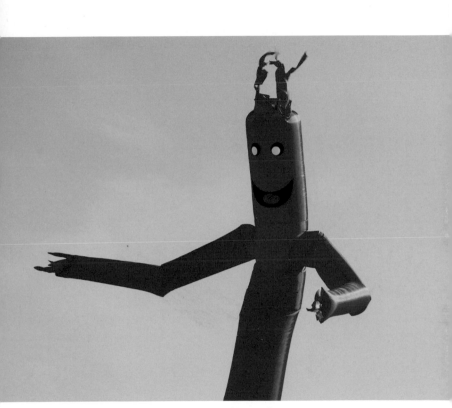

"Stab me. Please."

CREEPIOSITY INDEX: 7.15

HANKIES

Kleenex is a multibillion-dollar brand for a reason: They figured out that after you blow your hideous nose into something, normal people would much prefer to throw it out rather than save it (and get a pocketful of snot in the process). Lose the hankie, you animal.

And no, I don't want to borrow it.

Fred has also taken a
stand against toilet paper.

CREEPIOSITY INDEX: 6.81

CARS WITH TOO MANY BUMPER STICKERS

If you desperately feel the need to tell the world you owe, you owe, so off to work you go, then God love you. If your gentle taunt of "I may be slow but I'm ahead of you" is absolutely necessary in your book, hey, more power to you. If I can read this, yes, perhaps I am too close.

One, two, even three or four bumper stickers is excessive but acceptable. But when the entire back of your car is plastered with them, you've gone from hilarious satirist to creepy weirdo.

Do us a favor and save all that comedy for your blog.*

Photo credit: Richard Masoner

I'm starting to doubt his other car is really a Lexus.

*Which nobody reads.

CREEPIOSITY INDEX: 8.84

KIDDIE BEAUTY PAGEANTS

Ever since they were made popular by JonBenét Ramsey, these creepathons have taken over basic cable.

It's always the same cast of characters: the sexed-up toddler; the overweight, overbearing mom; the tortured dad; the gay emcee. Singing and dancing their way into hell (or Orlando).

Are these pageants creepy? Oh, sure. Are they Season Passed on my TiVo? You betcha.

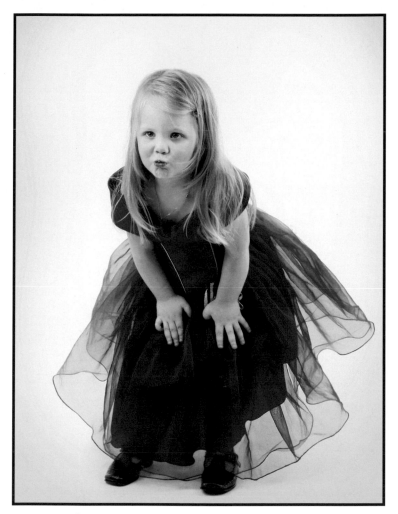

Oftentimes Samantha makes promises to the judges
she has no intention of keeping.

ADS IN THE *PENNYSAVER* THANKING ST. JUDE

Without fail, in every issue of the *PennySaver* (and I should know, I'm a longtime collector), there are a number of classified ads thanking St. Jude for "answering my prayers and helping Timmy find his dog" or "for getting me that dental office receptionist job."

Now, I'm no religious expert, but do these people really think that St. Jude is up in heaven playing gin with Danny Thomas, reading the *PennySaver,* and saying, "I'm glad Ethel appreciates who took care of those bunions for her."

All I'm saying is, let's keep religion where it belongs, people: in our public schools.

CREEPIOSITY INDEX: 7.61

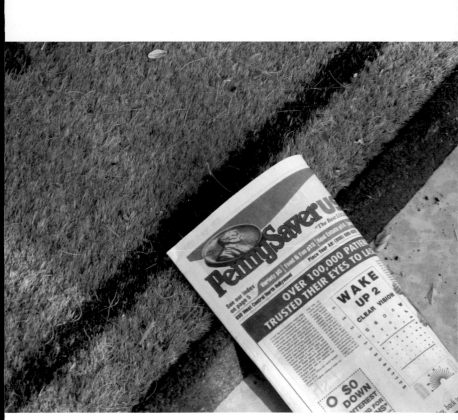

Catch the latest issue in a recycling bin near you!

ANNE GEDDES

Proof that there's a fine line between cute and creepy.

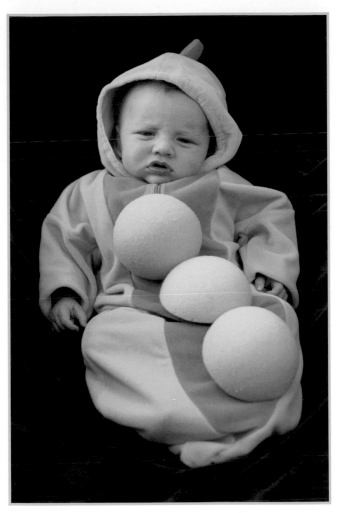

The Jolly Green Giant eats a hundred of these a day.

CREEPIOSITY INDEX: 5.98

KNOCKOFF CHILDREN'S PARTY CHARACTERS

The truth is, the people who make a living going to children's parties dressed as "Doreen the Adventurer" or "SquareShaped Yellow Sponge" look at the guy dressed as "Tigger" at Disneyland and think, "Someday, with St. Jude's help, that could be me!"

And that's just sad.

In his salad days, Russell Crowe worked birthday parties
as "Large Fowl."

CREEPIOSITY INDEX: 6.12

My mom would always bake me a urinal cake for my birthday.

THE GUY WHO PEES IN THE URINAL RIGHT NEXT TO YOU EVEN THOUGH THERE ARE TONS OF OTHERS AVAILABLE

Public men's rooms are bad enough as it is: You've got the guy who is way too comfortable pooping in a public place; you have the OCD guy who does everything with his foot like Daniel Day-Lewis; there are guys who hum too loudly, guys who fart too loudly, the guy who washes his face and dries it with the hot air blower; and once in a while you even get the guy who thinks it's OK to brush his teeth in there.

So let's not make it worse by ignoring unspoken boundaries, fellas.

But if you do insist on flanking me when I go please, *please,* no peeksies.

CREEPIOSITY INDEX: 7.79

CASPER

When we were growing up, nobody ever acknowledged the sad truth about Casper the Friendly Ghost, which was, of course, that he was a dead kid.

Then somebody had the bright idea to make a live action/CGI *Casper* movie, and not only did they let the cat out of the bag, they *dwelled* on the fact that this little boy had died. From a tragic illness.

So we take our kids to see it and now they're convinced they're gonna drop dead the next time they have a fever.

Which is terrible.

But here's what's worse: *Once you're dead, without fail, when people see you, they'll yell "G-g-g-ghost!" and run away so fast they'll leave their shoes behind.*

And that can't be good for your self-esteem.

Nancy has either seen a ghost or a used Band-Aid on the ground.

STYROFOAM WIG HOLDERS

They're in the shape of a head but completely white and with no defined facial features. My mother's, I'm sure, was out to get me.

Despite what anyone's told you,
I never tried to make out with her.

With wig on it: 8.79
With toupee on it: 9.31

WINKERS

They make up only an estimated 2 percent of the population, but their creepy impact on society is a force to be reckoned with.

No, not Jews! (How dare you!)

Winkers.

It's either used as a way to attract the opposite sex (although from experience I can tell you, I don't think that's worked since the 1940s), or, more commonly, as a nonverbal way of saying "Just kidding." Some examples:

"I'm on a seafood diet—whatever food I see, I eat!" (*wink*)

"Hey, who invited this guy?!" (*wink*)

"I'm going to kill your mom and cut her up and bury the pieces under my barn." (*wink*)

Here's a little hint to all you winkers out there:

It's not cute, it's not funny, and trust me, you come off as a freak. (*wink*)

"Just kidding, I'm not gonna tell your wife we've been screwing!"

CREEPIOSITY INDEX: 6.93

PEOPLE WHO ALWAYS WEAR GLASSES WITHOUT THEIR GLASSES ON

Once someone has established themselves as a glasses wearer, they don't look right unless they have them on. They switch over to contacts or have Lasik and all of a sudden, you get that uneasy feeling in the pit of your stomach.

Put the glasses back on, pal. Sure, you'll look older and not nearly as handsome, but at least I'll feel better inside.

Dreamy

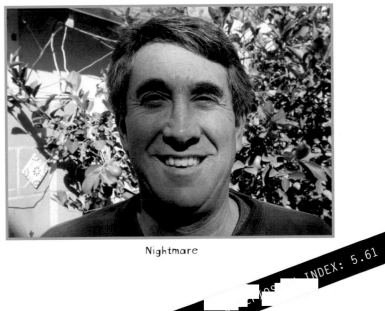

Nightmare

ACCIDENTAL INCOMPLETE FACE SHAVING

Shaving is a pain in the ass and on occasion you'll miss a tiny spot—that's understood; you'll get 'em next time, Champ.

But when you miss giant clumps? That's when you need to be sent home to put things right.

Dave likes to tell himself this was the only reason he wasn't voted *People*'s sexiest man alive.

CREEPIOSITY INDEX: 7.30

PASTE

Also known as the black sheep of the glue family.

reader to apply
e. Press
Ready to use
e after each use.

ds with clean
hile still moist
shes out of
water, even

Or as the slow kid
calls it, lunch.

CREEPIOSITY INDEX: 5.83

BEE BEARDS

Having never invited a swarm of bees to settle on my face and body, it's hard to say what the motivation behind this can be. To look cool? Nope. To impress the fairer sex? Negative. To make the rest of us really, really uncomfortable?

I think we've found our winner.

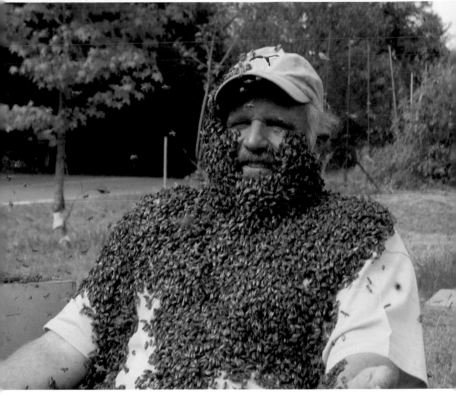

"Who said anything about 'invited'?"

CREEPIOSITY INDEX: 5.90

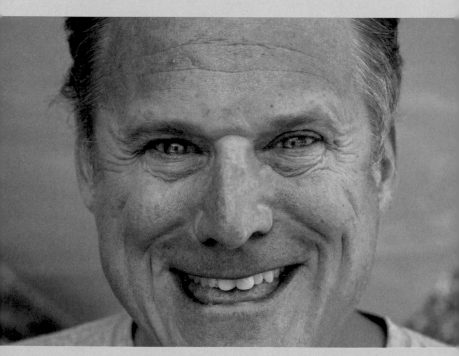

Mike Reuben, star of *Life Goes On: The Motion Picture.*

ACTORS AND ACTRESSES PLAYING MENTALLY CHALLENGED

From Jodie Foster in *Nell* to Sean Penn in *I Am Sam* to Rosie O'Donnell in, well, anything.

You're not only creeping us out, you're taking jobs away from regular retarded people, and that's not cool.

CREEPIOSITY INDEX: 8.98

ANY SCHOOL BUS
NOT BEING USED
AS A SCHOOL BUS

Used to take kids to school, a school bus is creepy enough. The beaten-up seats, the windows that never really open, the vague smell of vomit and sawdust . . .

But when it's been retired and is now used as something else—that's when it really gets bad. Whether it's now a bookmobile, a camper, or a pedophile's hangout, all are equally creepy.

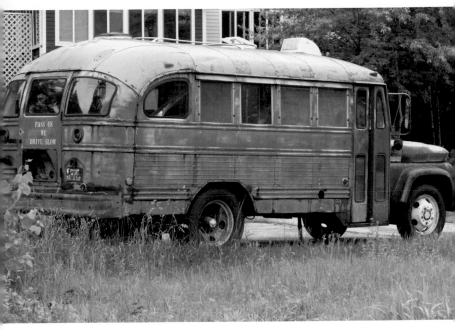

The Partridge family has clearly fallen on some hard times.

JOKERS

I don't mean jokers like "Hey that guy just dropped my Rolex in the toilet . . . what a joker!" I mean actual jokers, i.e., the first thing you throw out when you open a deck of playing cards.

It's an interesting phenomenon: No matter what brand of cards you get, the joker is always some creepy dude subtly mocking you. As if he's saying, "You're stupid, I'm smart!" or "You have a severe gambling problem and it's slowly driving an irreparable wedge between you and your family, Dave."

Jokers are assholes.

CREEPIOSITY INDEX: 8.73

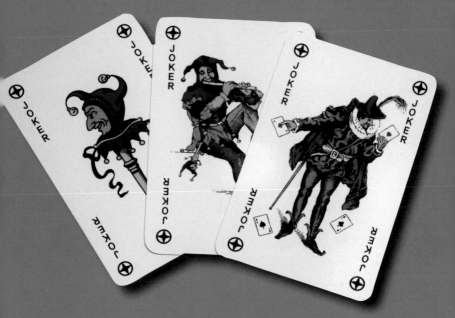

Probably drove the king of hearts to suicide.

BAD DENTURES

Don't you realize that when you're talking to me I'm looking at my feet?
Why do you think that is? Is it because I have such pretty feet (**My Feet**
Creepiosity Index: 8.10; **My Feet in Sandals**: 9.31)?

No, it's because your choppers look like crazy yellow Chiclets.

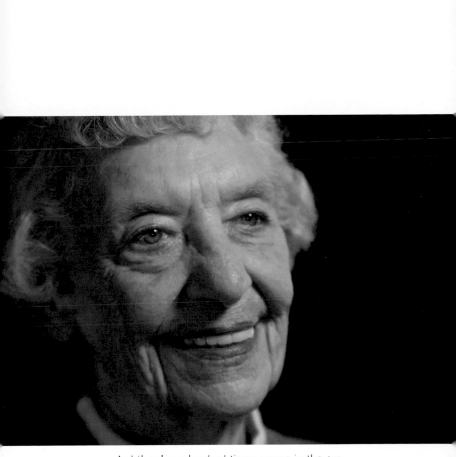

And they're a hundred times worse in the jar.

MR. MAGOO

Years and years ago, somebody decided that this would be a great idea for a children's cartoon: the adventures of an old blind guy who continually comes close to dying tragically as a direct result of his disability.

What kid doesn't love old people and the blind? And yet—*it was a huge hit*.

Now I'm torn. On one hand, I'm creeped out by the cartoon and the fact that it's been popular since before I was born, and yet at the same time I'm thrilled that there's hope for *my* breakout animated character, Deafsie McMute, America's Favorite Retarded Paraplegic.

The FAA deserves some of the blame
for giving Magoo his pilot's license.

UNSTUFFED BUILD-A-BEAR SKINS

It's like a tiny serial killer murdered the Snuggle Bear and removed his guts. What's next, he "wears" the pelt to lure other adorable stuffed creatures into his web of death?

I guess what I'm saying to my wife is, I don't care if it's our long-standing tradition—no more Build-A-Bear birthday parties for me ever again!

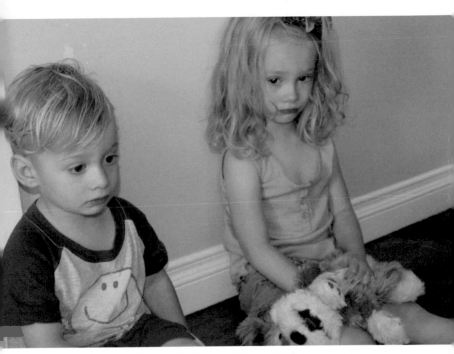

Turns out Ben and Julia aren't fans of lifeless corpses.

CREEPIOSITY INDEX: 8.72

NONBLINKERS

You know the guy or gal who just looks at you and doesn't blink? They're either robots from the future sent back in time to destroy humanity or just a really creepy human.

Either way, not for me.

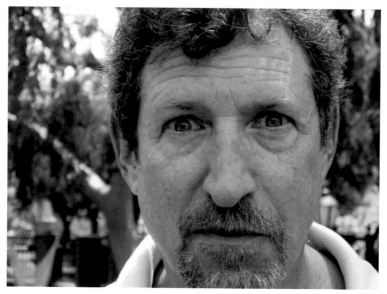

To be fair, Jeff lost his eyelids in 'Nam.

CREEPIOSITY INDEX: 7.69

WHITE KIDS WHO ACT LIKE BLACK KIDS

It's disturbing, these suburban kids who not only dress like, but also talk like, they're from some ghetto. What's with the accent, Federline? You're from Oregon! You know who was the last black person to live in Oregon?*

The interesting thing is that this phenomenon is almost completely limited to white kids trying to be black (aka "Wiggers"). You don't see white kids trying to act Chinese ("Winks") or Jewish ("Weebs"). Honestly, have you ever seen a white kid from Portland with a *yarmulke* and a *tefillen* saying, "I don't mix no meat and dairy, yo."

Bottom line is, we all hate you.

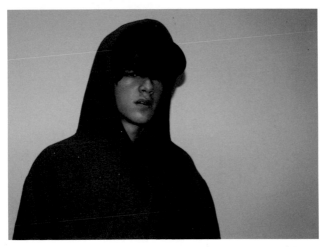

Z-Dog hopes rapping will be his ticket out of the ghettos of Scarsdale.

*Not a rhetorical question. I really don't know the answer.

CREEPIOSITY INDEX: 7.03

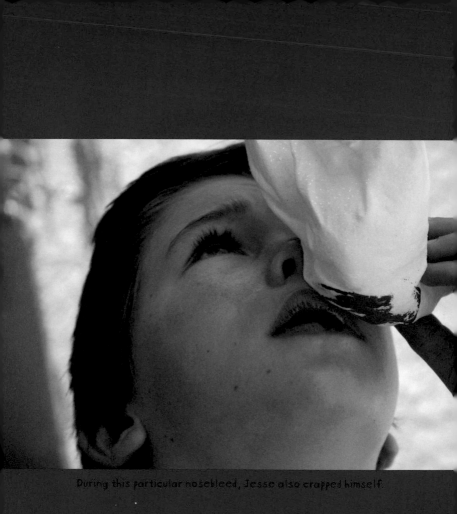

During this particular nosebleed, Jesse also crapped himself.

THE KID WHO ALWAYS HAS A NOSEBLEED AT SCHOOL

This might sound heartless, but the kid at school who always has a nosebleed, the kid who always throws up, and the kid who smells like he crapped himself should be isolated from the rest of the kids. I'm not suggesting a whole separate school, but certainly it's not too much to ask for a separate wing in the normal school for all the kids who can't control their bodily functions.

Or maybe a separate school.

FANTASIA

Old people always told us this was a classic and insisted we watch it. And they knew it was torture. Here's my theory:

We've always been told that every parent wants their kids to have a better life than they had—and I believed that until *I* became a parent and saw how great things are for my kids, most notably:

1. They have hundreds of TV channels. I had six and I usually had to turn the dial with a wrench.
2. They have DVDs. What did we have? View-Masters.
3. And they have the Internet.

The Internet!

Game over, they win.

And I hate them for it.

And our parents, while they lied through their teeth and said they wanted a better life for us, hated *us*. Because they were jealous that we had six channels of TV! And View-Masters!

And they felt that if they had to suffer through a creepfest like *Fantasia,* then we'd also have to. To get us back. Because they were jealous.

Trust me, kids, you'll be showing it to your children someday, too.

Probably right on your freakin' Internet.

CREEPIOSITY INDEX: 9.07

Based on a true story.

CANADIAN COINS

You ever wonder why candy machines won't take them? It's because they're strange and different. (And, of course, as my parents always taught me, anything strange or different is bad.) I'd be willing to bet that even Canadians find them a little creepy.

Here's my pitch to Canada, and this is free. (*Please* don't try to pay me for it in Canadian coins as a big ironic FU!)

Make your coins look and feel *exactly* like our coins, right down to the ridges on the quarters, only instead of presidents or buildings or the other cool stuff we have on ours, honor some Canadian heroes.* We'll all know they're second-rate coins, but the candy machine won't, and isn't that what really matters?

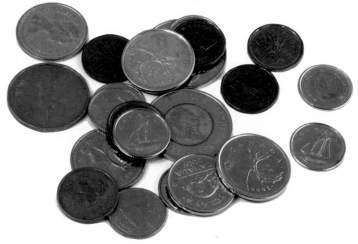

All that stands between me and a king-sized **Twix** bar.

*OK, there are no Canadian heroes. But Alan Thicke is pretty awesome.

JAPANESE CARTOONS (AKA ANIME)

Even as a boy, I knew in my gut that *Speed Racer* didn't look or sound right. The drawings were strange, the voices were stilted, and the characters didn't move with any fluidity. And yet it was a big hit, so I thought it must be me, and I forced myself to watch *Gigantor* and *Astro Boy,* squirming the whole time. It was my earliest submission to peer pressure (to be followed years later by alcohol, cigarettes, and a little bit of gay bashing).

If you disagree with me, that's your right (as a moron), but do me this favor: Go on YouTube and check out a show called *Panda! Go Panda!* It's about a little girl who befriends a baby panda and its father, with whom she establishes a sort of bizarre marital relationship. If you don't agree that it's one of the creepiest things you've ever laid your eyes on, I'll refund what you paid for this book.*

And to make it worse, a winker.

*Claim is made for dramatic purposes only. The author will not refund any money you paid for this book. But the show *is* pretty damn creepy.

NURSERY RHYMES

Kids are falling down and breaking their crowns, humanoid eggs are falling off walls and crashing to the ground, old ladies are cutting off the tails of mice—and not just any mice, *blind* mice.

Listen, I'm not an idiot—I know Mother Goose was a giant bird in a bonnet, so odds are she's gonna come up with some crazy shit. I blame *us*, for continuing to frighten our children with these verses of doom hundreds of years later.

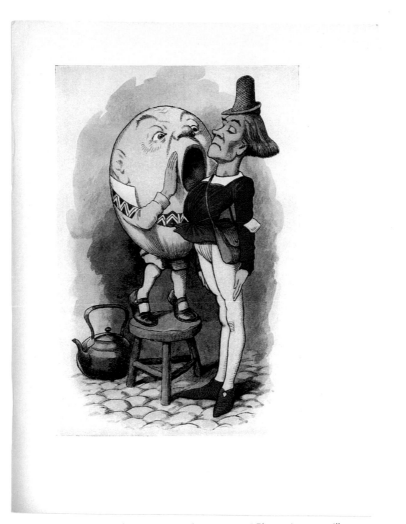

"Pssst . . . you're creepier than me, and I'm a giant egg!"

MONOCLES

When I was seven, the eye doctor informed me that while my left eye was perfect, my right eye wasn't. For some reason, I couldn't comprehend the idea that they'd give me glasses with a clear lens in the good eye. Instead I was sure I was going to have to wear a monocle.

OK, I was borderline retarded.

Here's my point: If monocles were anything but very creepy, I doubt I would've minded (in fact, it would've been pretty entertaining to the other second graders to comically let it pop out of my eye whenever I was surprised). But think about it, nobody cool or heroic ever wore a monocle. Colonel Klink, a Nazi (and worse, a buffoon!); Charlie McCarthy, a ventriloquist dummy—and those certainly aren't creepy; Mr. Peanut was kind of cool I guess, but he always came off a little arrogant for me, like he was better than the rest of us because he was a giant peanut. Well guess what, Peanut? *You can get glasses and have clear glass for your good eye.*

Idiot.

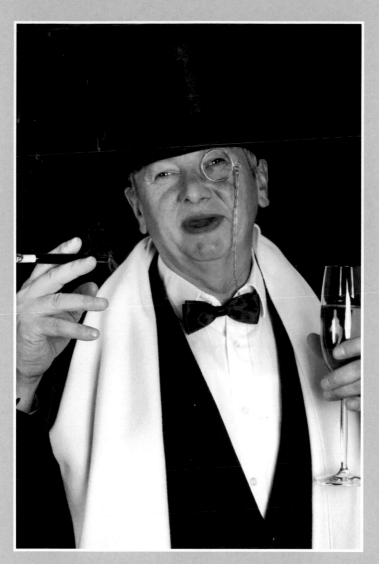

The author celebrates his latest book deal.

BEGGARS

An open letter to the homeless guy on Laurel Canyon and the entrance to the 101 Freeway:

Dear Sir,

First of all, what follows should be taken as constructive criticism. All in all, you're doing a great job (although I guess "job" wouldn't be the best choice of words). Anyway, I'm sure you don't hear this a lot, but your very presence creeps us all out a little (that's called "tough love"). So what I'd like to do is help you make the whole experience a little less disturbing for us and maybe get a few more nickels into your empty coffee cup!

First off, your appearance. So I don't sound like a complete Negative Nelly, I'll tell you what I like. The leathery skin works. It tells me you've been outside a lot, which homeless people are. Very believable. The clothes work well, too. The ripped and stained T-shirt really reads like you have no other clothes in the world—nice touch. The camouflage pants are a winner, though I would like to see the urine stains a bit more pronounced (the problem with camouflage).

As for your face, I love—*love*—the matted hair and beard. That's the difference maker. I went as a bum ("Hobo"? Grrr—I wish I were more PC) to my kid's private-school Halloween party last year and even though I looked really gross and pathetic, something was missing—the matted hair and beard! I went the lazy man's route, the ski cap and the burned cork "beard"—*lame*!

So those are the things I think are really working for you. Now the things that aren't.

Let's start with your sign. We'll break it down.

"GOD BLESS YOU." OK, not all of us are that religious, but it's a good headline, no denying that. Actually, funny story—I was driving down Laurel a few weeks ago and I sneezed, and as I opened my eyes, what do you think was the first thing I saw? "God bless you." Oh man, I laughed. In retrospect, it probably looked like I was laughing at you, but really, I was laughing with you.

"I HAVEN'T EATEN IN A WEEK." OK, that goes under the assumption that you make a new sign daily, which I doubt you do. In other words, will tomorrow's sign say "I haven't eaten in a week and one day"? You see what I'm getting at? Instead, how about a one-word grabber: "Hungry." Or "Starving." That might be a bit more elegant.

"MY FAMILY HAS AIDS." OK, gotta be honest—this is a real downer. Can you bang it down to the mumps or maybe the flu? Or maybe something like, "Me no feel so good!" (All I'm saying is, funny sells.)

The only other part that bumped for me is when you wrote you were a homeless vet. Now to me, you look around fifty or so, although admittedly it's hard to gauge, what with the leathery skin and the matted hair. If you are fifty, I have a hard time figuring out what war you're a veteran of. 'Nam seems like the most likely war for you, but that ended probably around thirty-five years ago, so you're too young for that. And yet you seem too old for either of the Gulf wars. So right out of the gate, I'm skeptical—unless, of course, you meant that you're a veterinarian, which would explain the pretty healthy looking dog you have with you. If that's the case, you should clarify.

Anyway, that's enough of my jabbering. I have plenty more thoughts (That shopping cart has to go! Depressing!), but I don't want to overwhelm you. I just figured, sure, I can give you a handout, but in the long run, my advice would be worth a lot more.

Sincerely,
Dave

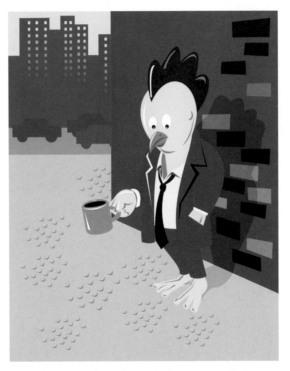

Glen was the richest chicken in New York until the Madoff scandal.

IMAGINARY FRIENDS

It's supposed to be adorable when three-year-old Dylan talks to his imaginary friend "JoJo," but it's not. It's creepy.

Because if Dylan were fifty instead of three he'd probably be talking to "JoJo" from inside the cuckoo's nest.

Michael leans in for the kiss that never really comes.

CREEPIOSITY INDEX: 8.11

GUYS WITHOUT ANY SIDEBURNS

God bless Bruce Hornsby. I'm a huge fan. "The Way It Is" is a really sweet song, and I'm sure he has some other good ones (that's just a guess). But for all his talent, I always found it hard to look at him. It took me awhile to figure out why and then it hit me: no sideburns. At all.

Now look, Bruce, I'm not asking you to be Neil Diamond or Fat Elvis, but without *any* burnage at all, you look a little creepy.

Again, big fan. Of that song at least.

Bruce Hornsby singing, hopefully, "The Way It Is."

CREEPIOSITY INDEX: 7.22

NECCO WAFERS

Every March at the annual creepiologist convention (held at an abandoned carnival in Upstate New York) we have a lot of fun debating creepiosity levels. This year, the discussion turned to candy, and it got a little heated.

The room was basically divided into two camps: those who thought black Chuckles were the creepiest candies, and the more intelligent group who knew for a fact that NECCO Wafers were way creepier.

The case for the NECCO Wafers is clear-cut: They're pastel-colored (candy is meant to be colorful), they taste like shit (candy is meant to not taste like shit), and they're reminiscent of Communion wafers, breaking the number one rule of candy: It's not supposed to remind you of religion in any way.*

Sure, black Chuckles are creepy, but to compare them to NECCO Wafers is like comparing apples to oranges (apples are the much creepier fruit).

I like them better under their other name, Tums.

*Jujubes are creepy for the same reason.

CREEPIOSITY INDEX: 6.14

ANYTHING BEING PUSHED IN A BABY CARRIAGE THAT ISN'T A BABY

Maybe it's your groceries, maybe it's laundry, it might even be your dog. It doesn't really matter. *If you're pushing something in a baby carriage that isn't a baby, you are creeping us all out.*

And if you're carrying anything besides an infant in that Baby Björn, you really need some help.

Minutes before Tania tried breast-feeding her cactus.

CREEPIOSITY INDEX: 9.18

ADS THAT ARE SUPPOSED TO LOOK LIKE THEY'VE BEEN DESIGNED BY LITTLE KIDS

For some reason, advertisers think that if their ad looks like a four-year-old designed it, we're going to think it's adorable. Only problem is, we all know that a fifty-five-year-old man designed it, and that creeps us out.

This is an ad that appeared on a billboard in Los Angeles not too long ago:

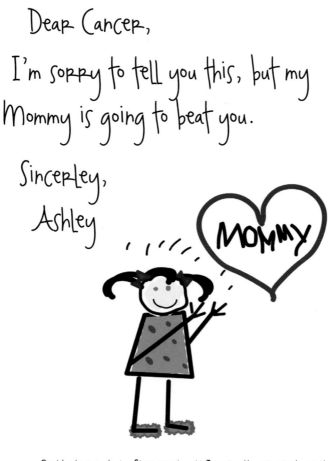

Dear Cancer,

I'm sorry to tell you this, but my Mommy is going to beat you.

Sincerley,
Ashley

MOMMY

God help me, but after seeing it **I** actually started rooting for the cancer.

INFOMERCIAL DOCTORS

Imagine you're watching an informercial for Ronco Ass Whitener or the Gerry Cooney Grill or whathaveyou. And when it's time for the doctor's endorsement, the doctor they trot out is *your doctor.*

YOUR DOCTOR: "I've used a lot of ass whiteners in my day, and Ronco's is the best!"

Now do you (and his other patients) sit there and think, "Cool, my doctor is on television"? Or do they think, "Oh no! Creepy! My doctor is a whore"?

On the upside, a whorish doctor is probably pretty fast and loose with the Vicodin prescriptions.

CREEPIOSITY INDEX: 8.02

Dr. Schwartz's real dream was to be one of Charlie's Angels.

LUCY IN COLOR

Watching *I Love Lucy,* in glorious black-and-white, the lady was hilarious. She was America's favorite wacky redhead, even though on TV, she was a grayhead.

Once we saw her in color, though, she somehow stopped being funny and started getting kinda creepy.

Sadly, the combination of the ultrabright red hair, the precancerous smoker's voice, and the attempt to do physical stunts when she was one banana peel slip away from a broken pelvis made color Lucy hard to love.

Little-known fact: Lucy and Prince had the same costume designer.

CREEPIOSITY INDEX: 8.86

LITTLE LEAGUE UMPIRES WHO TAKE IT WAY TOO SERIOUSLY

We've all had dreams. I tried to be a professional gambler, although that didn't work out. Perhaps focusing solely on scratch-offs was my downfall, but ultimately I'm better off for it. Not only am I now universally respected as the world's leading creepiologist, I no longer have to worry about constantly cleaning scratch-off residue from my clothes and furniture.

Others haven't adapted as well to a failed dream, most notably the guy who couldn't cut it as a major league (or minor league, or college, or high school) umpire and makes up for it by umpiring children's baseball. Yes, you still get to dust off the plate, but it's a lot harder when the tee is sitting on it; sure, you get to yell your signature "You're *ooooooooooout!*" but the tears of the five-year-old strikeout victim, as cute as she is, is a cold reminder that this ain't Pujols you're sending to the dugout.

On the plus side, sometimes the team mom does have an extra packet of postgame gummy fruit to share with you, and that's pretty awesome.

CREEPIOSITY INDEX: 7.12

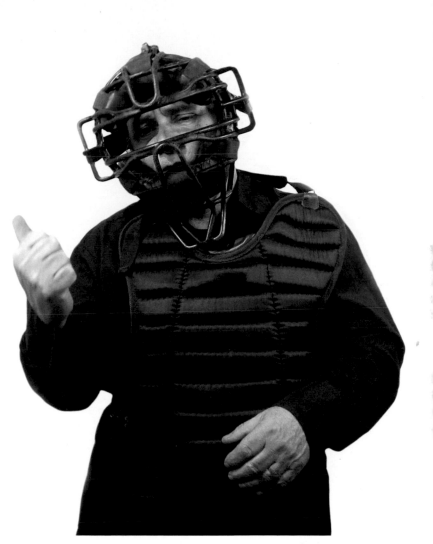

It's widely known that Paul will throw a game if you play
"Find the baseball in my pocket" with him.

THE AUTHOR

David Bickel is a veteran TV writer and producer whose credits include a nine-year stint on the award-winning series *The King of Queens*. He is currently writing and executive producing a series he developed for the Walt Disney Company.

David lives in Los Angeles with his wife and kids and ten cats.

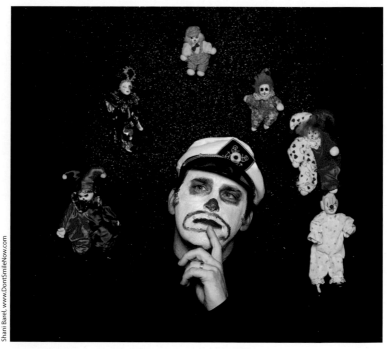

Sorry, ladies —he's taken.

CREEPIOSITY INDEX: 9.72

CONGRATULATIONS!

You've just read an entire book!

Besides an overwhelming feeling of accomplishment, you're probably a little sad, and you know what? That's OK.

Here are four ways you can shake those doldrums:

1. Buy another copy and read it again.
Sure, you could just reread this copy, but don't you miss that new book smell?

2. Buy a copy for all of your friends.
Unless you're friends with Dick Cheney or Bazooka Joe. We don't want to hurt anyone's feelings.

3. Check out the official Web site of all things creepy:
www.creepiosity.com
It's more fun than a barrel of red-ass monkeys!

4. Tell us what you think is creepy!
Send your ideas to Creepy@creepiosity.com
Who knows, maybe we'll publish them in the next edition!*

*By submitting ideas or suggestions ("Contributions") to Creepiosity, you agree that:
(a) Creepiosity is not under any obligation of confidentiality, express or implied, with respect to the Contributions; (b) Creepiosity shall be entitled to use or disclose such Contributions for any purpose in any media worldwide; (c) your Contributions become the property of Creepiosity without any obligation of Creepiosity to you; and (d) you are not entitled to any compensation or reimbursement of any kind from Creepiosity under any circumstances. But you will (e) feel pretty cool having your idea in print. And who knows? Maybe it'll help you (f) that certain young lady you've had your eye on.

ACKNOWLEDGMENTS

A lot of people have been instrumental in my journey from street urchin to the world's leading creepiologist (and, ultimately, back to street urchin).

First and foremost, Dr. Edgar P. Reisdorf, who took a chance on a kid with a dream and helped make that dream a reality. Was he a bit of an octopus when we were alone together? Sure. But in fairness, I did dress rather provocatively back then. Other mentors include Lowell Ganz, William Goldman, Jonathan Stark, Tracy Newman, David Litt, and Michael J. Weithorn.

Big thanks to all the people who lent their faces and/or brains (metaphorically speaking, for the most part) to this project: Cliff Kaplan, David Goldhaber, Curtis Wilmot, Joseph Garvin, Marisa Garvin, Mike Granberry, Michael Bickel, Zachary Bickel, Marc Sedaka, Michael Sedaka, Amanda Sedaka, Charlotte Sedaka, Rock Reuben, Tania Reuben, Ben Reuben, Julia Reuben, and Jeffrey Ganz.

And to those who pushed, prodded, and cajoled me to get all my years of research into print: Dennis Palumbo, Kathy Green, and Lane Butler. I don't have the words to thank you enough, but hopefully a gift basket from Hickory Farms can do the trick.

But more than anyone, my unending gratitude must go out to the three least creepy people I know: Judy, Camden, and Jesse. You guys will be thanked in more detail when, God willing, I'm awarded the Nobel Prize that Dr. Reisdorf didn't live long enough to win.

INDEX

Subject	Rating	Page
Petting Zoos	8.88	34
"Can You Read My Mind?"	8.87	56
Lucy in Color	8.86	176
Cars with Too Many Bumper Stickers	8.84	117
Styrofoam Wig Holders (with Wig)	8.79	130
Jokers	8.73	144
Unstuffed Build-A-Bear Skins	8.72	150
Kids on Leashes	8.68	86
Casper	8.61	128
The Song "Mockingbird"	8.56	14
Your Grandma	8.51	2
The Drive to the Service Station with the Tow-Truck Guy	8.50	97
Old Ladies with Really Long Hair	8.47	92
The Nurse's Office at School	8.28	64
Bad Dentures	8.24	146
Lily Tomlin as the Little Girl in the Big Chair	8.16	98
The Good Humor Man Who Asks Too Many Questions	8.16	106
People Who Are Fluent in Made-Up Languages	8.12	99
The Kid Who Always Has a Nosebleed at School	8.11	154
Imaginary Friends	8.11	167
Your Religion	8.11	10
Grandma Candy	8.10	104
Bruce Jenner's Face	8.10	70
Men with Vastly Unrealistic Dyed Hair	8.10	94
Lipstick on Anything Besides a Woman's Lips	8.02	67
Infomercial Doctors	8.02	174
Japanese Cartoons (aka Anime)	7.99	159
Popeye	7.97	80
Ads That Are Supposed to Look Like They've Been Designed by Little Kids	7.97	172
Mr. Magoo	7.91	148
Strippers/Porn Stars with Black-and-Blue Marks	7.89	68
Animal Mascots Who Want You to Eat Their Kind	7.80	36
The Guy Who Pees in the Urinal Next to You Even Though There Are Tons of Others Available	7.79	126
HBO's Real Sex	7.77	82
Dick Cheney Smiling	7.71	6
Toy Train Aficionados	7.71	60
Nonblinkers	7.69	152
Renaissance Fairs	7.62	102
The Uncle Wiggily Game	7.62	88
Grown-Ups with Pigtails	7.61	54
Ads in the Pennysaver Thanking St. Jude	7.61	120
Andy Rooney's Eyebrows	7.55	83

Subject	Rating	Page
Opera Singers	7.55	84
Band-Aids That Were Once Affixed to Someone's Body but Now Aren't	7.45	20
Bingo Zealots	7.40	78
Accidental Incomplete Face Shaving	7.30	136
Bazooka Joe	7.27	4
Monocoles	7.23	162
Guys without Sideburns	7.22	168
The Blowy Guy in Front of the Mattress Store or Car Dealership	7.15	114
Tony Randall Dads	7.14	47
Sea Monkeys	7.14	40
Little League Umpires Who Take It Way Too Seriously	7.12	178
People Who Make Their Maids Wear the Maid Uniform	7.03	112
White Kids Who Act Like Black Kids	7.03	153
Glinda the Good Witch	7.02	16
Bars of Soap	6.98	12
Winkers	6.93	132
Beggars	6.91	164
People Who Hold the Handshake Too Long	6.91	48
Old-Tyme Porn	6.87	42
Hankies	6.81	116
People Who Drive Really Old Cars	6.71	62
Mom-and-Pop Supermarkets	6.70	72
Little Kids with Old-People Names	6.45	50
Pictures of the Dishes on the Wall at the Chinese Takeout Joint	6.25	58
NECCO Wafers	6.14	169
Knockoff Children's Party Characters	6.12	124
Anne Geddes	5.98	122
Canadian Coins	5.94	158
Bee Beards	5.90	138
Paste	5.83	137
Guys with Beards but No Mustaches	5.75	22
People Who Always Wear Glasses Without Their Glasses On	5.61	134

Follow
all things creepy
at
www.creepiosity.com